The Water's Edge

OpenEyeGallery

LIVERPOOL
UNIVERSITY PRESS

The Water's Edge

Joanne Lacey
Michelle Sank

Open Eye Gallery
Liverpool University Press

First published 2007 by
Liverpool University Press
4 Cambridge Street
Liverpool L69 7ZU

and

Open Eye Gallery
28-32 Wood Street
Liverpool L1 4AQ

British Library Cataloguing-in-Publication data
A British Library CIP record is available

ISBN 978-1-84631-084-3 cased

Designed by Alan Ward @ www.axisgraphicdesign.co.uk
Printed and bound in Italy by Editoriale Bortolazzi Stei, Verona

cover:
Blaze
Dancer

Pier Head

Contents

Foreword

2007 marks the 800th birthday of the Borough of Liverpool, which was created by Royal Charter in 1207. To mark the occasion, Open Eye Gallery has produced *The Water's Edge*, a photographic commission, exhibition and book that explores a neglected area of the city's cultural history. It focuses on the women who work, or worked, in and around the city's waterfront, or who left Liverpool to work away at sea.

The project grew out of the stories collected by Dr Joanne Lacey in the 'Working at the Edge of the World' sound archive. In 2005 Joanne and I agreed to commission a photographer to work with the women who had contributed to the archive. After a period of research and discussion we approached Michelle Sank, whose sensitive and incisive portraits of young people had impressed us both. We invited Michelle to make a number of trips to Liverpool throughout 2006, with the object of creating a series of portraits for *The Water's Edge*.

The resulting works accomplish something extremely rare in contemporary photographic portraiture. They allow each subject her dignity and integrity as an individual, while at the same time giving, through small but telling details, a glimpse of what is hidden within. This and many other aspects of Sank's photographs are discussed in detail in Roy Exley's lucid essay '"In a Man's World": Michelle Sank's Women of the Liverpool Waterfront'.

At the heart of the project, alongside Sank's remarkable portraits, are the myriad voices of the women she has photographed and of the other contributors to the sound archive. Joanne Lacey's essay 'Journey to the Water's Edge' tells the story of the making of the archive and of its roots in her own family history. Its central focus, however, is a series of short quotations taken directly from the archive. Each one of them is a fragment of an extraordinary individual history. I'd like to thank Joanne and Michelle for their creative contributions and hard work, and all of the project's participants for their patience and generosity.

Patrick Henry
Director, Open Eye Gallery

Journey to the Water's Edge

Joanne Lacey

Beginnings are both something one does and something one thinks about.
The two sometimes go together.
Edward Said, *Beginnings, Intention, Method*

1 There are still some stories to be recorded.

In November 2004 I began recording the first of 50 interviews for 'Working at the Edge of the World', an archive of stories, memories and reminiscences that looks at women's work and involvement on the Liverpool waterfront from 1939 to now.[1] It looks at both formal and informal economies, and voluntary and political activity. The interviewees include barmaids and landladies, female dockers working today, prostitutes and dancers, Port of Liverpool police, catering workers, a social worker, merchant seawomen, the Panamanian Consul, bag warehouse workers, the ship's master of a Tall Ship, ships' cleaners, nurses, a ships' painter, a tram clippie, railway workers, WRNS, Seamen's Mission employees, and Women of the Waterfront, the wives and partners of sacked dockers from the 1995 docks dispute. The oldest woman to participate was 98, the youngest 19. Women's work and involvement on, in and off the Liverpool waterfront is under-represented in existing historical archives. In this context, the stories of the 50 women (and one man, Les Heather, who started to hire women back onto the docks in 1995 after a fifty-year absence) are vitally important historical documents. This is a unique collection – without it there is a gap in maritime history, without it there is a gap in local history, without it we miss out on the moments of extraordinary ordinariness that mark the lives within it.

My first interviewee was Mary, who had been a ships' painter during the Second World War. Mary didn't feel that the story she had to tell would be 'very interesting', but she made me tea and fed me gorgeous chocolate macaroons and began to talk. As she talked Mary made history – I mean properly made history. Mary was apologising because she hadn't, in her terms, had an adventure worth talking about – she hadn't been bombed off the docks, she hadn't fallen overboard. But what she had done was work that, before the war and indeed after it, was defined as 'men's work'; what she had done was outlive two of her children, carry that pain into everyday life and keep going. Mary's interview was incredible because of the matter-of-fact way in which it blended deep personal pain, family history, labour history, maritime history, wartime history and ideas about what it means to be a woman at work. My dominant memory of Mary's interview is the fact that she worked on the ships in a white boiler suit and a pair of wedge-heeled sandals. It's an extraordinarily evocative image of a woman in 'a man's world' hanging onto her femininity.

The diverse ways in which women have been part of the docks, the port, the river and related markets, industries and opportunities, either formally or informally, is itself a living, breathing and ongoing history. 'Working at the Edge of the World' represents a part of that history and some, but certainly not all, of the women involved in it. There are other stories that I couldn't find, particularly among Liverpool's ethnically diverse communities. I spoke to local historian Ray Costello, who has worked extensively on the history of the waterfront from the perspective of the black community, about the specific difficulty in tracking down black women's history in relation to the docks. He suggested that 'the finding may be that there are no stories to find, or that the search will be a very lengthy one', because the labour history around the docks (aside from the seafarers themselves) is predominantly white British. I hope that somebody does find them and record them, because I believe that they must exist somewhere. More stories will emerge as the years pass and the dock area, port and river change.

Like many people in Liverpool, my family history is connected to the river. My Irish ancestors were carried to the city on it. My grandfather, Jimmy Nyland, was in the Merchant Navy in the First and Second World Wars, in the First seconded to the Royal Navy on minesweepers (he lied about his age to be taken on) and in the Second as a stoker, a donkeyman (this is a painful image). My other grandfather, Bill Lacey, was a ships' carpenter. I was taken to the Pier Head as a child by my granddad, the donkeyman, to eat doughnuts and look out towards the bar and beyond. I'd like to say that he told me lots of stories of his time at sea, but he really wasn't much of a talker in any context, this included, and it was the being together, the looking out, and the wondering what was going through his head that mattered. My mother and his other daughters filled in, and told his stories for him when he wasn't around. They were big stories, adventures at sea, being torpedoed, visiting new countries, foreign ports, buying fantastic stuff to bring home. He was both traveller and adventurer, and I wanted a slice of what he had experienced. It fitted my romantic image of what happened beyond the bar. We knew his stories before official archives began to recognise the invaluable contribution that the Merchant Navy had made to the war.

In 1990 two events came together that really began to germinate the idea for 'Working at the Edge of the World'. My grandmother, Mary Anne Nyland, died that year. After the fact, I learned that she had worked between 1957 and 1960 on the docks as a ships' cleaner. She and other teams of women, largely drawn from the Scotland Road area, came onto the docks and the cargo and passenger ships with their buckets, cloths and brushes and scrubbed the outside decks and public areas. It was an informal economy of female labourers, recruited locally by a 'leading hand', called the blocker woman. In the hierarchy of family storytelling, my granddad's sea stories took priority over hers. This isn't a criticism of my family, which, like any other, prioritises certain stories over others. In all fairness, as a child I wouldn't have found her stories very interesting – no romance.

In the same year I also started a Masters degree. I read extensively around social history, theories of class and conflict, class identity, and just felt that there was something missing in it all. It felt cold, lifeless, prescribed, derivative. I read a quote by Carolyn Steedman that refused to leave me: 'there are lives, real lives, and then there are the theories that seek to explain them'.[2] In Steedman's terms there is a gap between lived history and the descriptions of lived history. There is an absence of fundamental feelingness, the hopes, dreams, fears, longings, routines, security that make up the fabric of human history. If I wanted to know what history meant to people, then I figured I had better just ask them.

2 Carolyn Steedman, *Landscape for a Good Woman*, Virago, 1986.

At that point, my passion as a social historian developed, and I turned my attention to collecting the stories of everyday life. Everyday lives matter; they are the stuff and stuffing of social history. Oral history, in one form or another, is the route to access the lived experiences of everyday life. Its value lies in offering an interpretation of time and place as it was/is experienced and lived by real people. The texture of the human voice gives to the telling a nuanced account that does not easily purge history of emotionality (suffering, joy, cruelty, conflict). It allows us to understand how history felt.

I started to think a lot about Mary Anne and Liverpool and the docks and the river, and the story that she never told. I should have talked to her more. I wished that I knew what Mary Anne's river and Mary Anne's docks were. I doubted that they were my romantic places of movement and escape; I suspected that they were deeply pragmatic places to earn a living, to keep going. I didn't know the answers, and I knew nothing of women's experiences on the docks, the waterfront and out at sea. Thus, the story that Mary Anne never told became the catalyst for a project that in itself became a romantic quest for a lost story. It was a slow-burning quest that lay dormant for another thirteen years.

In the summer of 2003 I moved back to Liverpool. Once I was back there, close to the river and the docks and the waterfront, the remote desire to do 'something' about Mary Anne's story gathered an intensity and focus. I had begun to ask my mother and her sisters questions about my grandmother's work, especially about the ages of the women and the dates when they had worked in this informal industry. By their and my reckoning if I didn't find these women now, then it would be too late.

I began by looking for material that might already exist, hoping that there wouldn't be anything and fearing that there would be. The archive at the Maritime Museum seemed a logical place to start. To my relief there was very little documentary evidence of this female industry in Liverpool. There was one vitally important study which had been done by the organisation 'Second Chance to Learn', under the guidance of course tutor Eileen Kelly. This oral history study covers more than sixty years of women's work on the Liverpool waterfront, from 1916 to 1985, and includes a section on ships' cleaners. The findings are written up in a booklet, 'Women's Work on the Waterfront', which was published in 1986. To the best of my knowledge,

this is the only research that exists on ships' cleaners in the UK, and possibly internationally. However, most of the ships' cleaners interviewed are now dead, and unfortunately the original recordings were not kept. I spoke to Eileen Kelly who said that finding women back then was an enormous challenge, and confirmed that the industry had all but stopped by the late 1960s. She was incredibly helpful in her advice on the search, but suggested, pragmatically rather than cynically, that I might now be chasing something very elusive.

I sent a letter to the *Liverpool Echo* in October 2004, asking for women who had worked as ships' cleaners to contact me. I also half-heartedly included a call for women who had worked on and around the docks in any capacity to get in touch. The response was huge, and while not all the people who contacted me fitted what I (thought I) was looking for, this route brought me into contact with some vitally important histories, especially from the war and the 1950s. I didn't initially get any ships' cleaners, but some of the daughters of ships' cleaners did get in touch, and a bit later Doris, who had worked as a ships' cleaner, contacted me. I had enough women to start interviewing. Mary was my first interviewee. I recorded her story because objectively I recognised its historical importance, but it was not (yet) emotionally relevant to me because she wasn't a ships' cleaner. A meeting in December changed all of that.

On a wet afternoon I took myself off to a meeting of the Liverpool Retired Seafarers Association, who met weekly at the Eldonian Village. I was full of hope that I would find people who knew ships' cleaners. I didn't, but I did meet two women who gave 'Working at the Edge of the World' an identity that it was lacking. I sat at a table with two fabulously glamorous blonde beacons of femininity, who had Tupperware boxes of sandwiches and sausage rolls.[3] They were Lorna and Bretta, retired stewardesses. They began to share some of their experiences at sea, the kinds of work they did, the laughs they had, how hard it could be, the places they had seen. They were passionate and articulate storytellers who asked the killer question: 'why are you only looking for ships' cleaners when there is so much more to say?'

From that point, 'Working at the Edge of the World', now sure of itself, of what it was and what it needed to do, really began to move. It would look at women's work on the docks, waterfront and at sea, and this would include ships' cleaners. The initial letter to the *Echo* had established many rich contacts who I felt renewed energy for. A slot with Roger Phillips on Radio Merseyside later in 2005 delivered more women, including a real surprise. The son of the last surviving female docker (there were five) from the Second World War contacted me to say that his mother would be interviewed. She was Kitty, who is now 98, looks 80 if she's a day, and had the wonderful temerity to tell me that I'd stand more chance of getting a fella if I took a leaf out of her book and wore a bit of powder and lippy every day.

As I interviewed more people, the project generated its own momentum, stories turned into other stories, contacts were made, networks established, somebody knew a man or a woman who knew somebody

3 Food is an ongoing theme in this project and though I don't have time to talk about it here, I salute all of you who fed me!

else. I was moved by the generosity through which and with which people moved this project forward. Without people to speak to it was nothing, and without the help of many people I wouldn't have found some of the women. The territory expanded and new knowledge was created.

After a while I started to look at the project differently. I had been very wrapped up in the search and record stage, and began to think about what I would do with the material. The obvious immediate choice for the interviews was to put them into an archive. National Museums Liverpool had funded 15 interviews, and had begun to formulate its '800 Lives' website, which seemed like an appropriate place for them to live, before becoming part of the museum's permanent collection. But I also wanted to bring these histories to life in a more visual way. I wanted these women to be seen as well as heard.

By this stage I had met Patrick Henry who was newly in post as the director of Open Eye Gallery. I spoke to him about the project and about my desire to create a visual output as well as an oral archive. I said that I was looking for an artist who would 'get it', who could understand that I wanted portraits that showed women rather than women at work. I didn't want to be part of the creation of social documentary, I wanted to surprise people. Patrick met Michelle Sank and had the vision to see that she would indeed 'get it'. I could see in Michelle's work that she had a profound ability to capture the compelling essence of a person. Her images were authentically human, revealing an innate respect for people and a genuine interest in what makes them tick, who they are, and who they are in the process of becoming. Open Eye Gallery commissioned Michelle to produce a series of portraits of some of the women interviewed. It was clear that the photographs would become a separate but connected means of representing the women and their lives. Michelle would have her own way of working, as I did mine; she was not there to represent or replicate my interpretation of an individual woman from my experience of interviewing her. We agreed that the interview was one encounter, and the space of being photographed another. Each encounter was a distinct and separate interaction and would deliver its own unique portrait of a life.

My hope is that, together, 'Working at the Edge of the World' and *The Water's Edge* create a contemporary and diverse picture of the Liverpool waterfront. I hope that they encourage us to look at the waterfront as a changing space where gender, work and life interact, and that the stuff of these lives – the dreams, hopes, fears, abuse, violence, love, gifts and talents, restrictions, romance, politics, global change, social change, local change, self-realisation, disappointment, tragedy, endurance, optimism, birth, death, femininity, sexuality, humour, sadness, nostalgia, the future – gives the waterfront new meaning.

Stories from the Water's Edge

This section draws together some extracts from the interviews. Some but certainly not all of the women are represented here. These fragments give a flavour of the richness of the material and a glimpse into the lives of some of the women represented in the photographs.

When we were on the railway itself in Wallasey, we used to put the hooks in and all that. I had a docker's hook to pull things out of vans. They had two men on the lorries, and I used to volunteer to go 'second man' because you got more money on that, the dockers used to come and take the stuff off us. We had a good time, we enjoyed it. The dockers used to get on the lorries and lash them, get the ammo out. Then they'd say to you, go on girl, go for your welt, they had no canteen, they called it the cookhouse then. So they'd get in the wagons and do our work while we had our break. We liked it on there because we got 7 o'clock in the night overtime... people call it the good old days. You know people say how you could leave your door open. Nobody had anything to steal anyhow so you could leave your door open, let's put it that way... we were just ordinary women getting the money in.
(Kitty, docker, 1939–1945)

Dear Kath, hoping you and Mike and the kids are well. How is your dad and all at 28? I am always thinking about you all, what kind of Xmas did you have. I hope you all enjoyed it, but it will be nothing to when I pay off, ha ha. We will have a ball. Joey Tremarco missed his ship in New York one of the lads was telling me. Kathleen one of the stewardesses tried to go over the side last night. I will tell you about all the carrying on when I get home. We are getting into New York in the morning so I will be looking forward to some mail. Kath I can phone you from New York, it is £1 a minute but it will be worth it to hear your voice. This is the second cruise over, please God it will slip by the time can't come quick enough until I get home.
(letter home, 2 January 1967, Maggie, stewardess, 1963–1967)

I volunteered to go on the *QE2* to discharge soldiers in the Falklands. I was a chief stewardess on the *QE2* anyway. When we finally got to Goose Green for them to go onto the *Stanley* it was like something out of a movie. The top deck of the *QE2*, all the swimming pools had been covered over to make helipads and there were guns all round the ship's rail. It was eerie, like one of those places you see in an atmospheric film, foggy with just the ducks swimming around. It was horrible. We dropped them all off. The hospital ship was P&O, there were about three other ships and we were all in a ring discharging soldiers and taking on supplies. The next thing for no reason, the ship went Phew!!!! Away, gone, and then we heard about the *Atlantic Conveyor*, and from the air the funnel was like the *QE2*, they thought it was the *QE2* and bombed it ... we did take on two Argentinean prisoners, one was only 15, and everyone fussed him. They were told that the British ate them! One of the hairdressers was on board and she cut their hair for them, in the end they didn't want to leave the ship, but it was over by then and they had to.

(Joyce, stewardess, 1964–1984)

I was sick all the way to Montreal, for five days. I still turned in for work everyday, but I didn't eat. But when we came down the St Laurence and I saw Montreal I forgot all about being seasick!

(Lorna, stewardess, 1967–1973)

I don't think you can say it's as black and white as a woman on a street corner dipping down to a car window and saying do you want some business, it's the same as the girls in the saunas, a guy comes in, pays his money and says 'I'll have her'. Around this area, the docks and the seafarers, it's all muddled up and hazy grey ... just like the woman who says to her husband, there'll be no more sex in this house till you get me that new three-piece suite that you've promised me. If you use sex as a bargaining tool isn't that prostitution?

(Linda, project worker [sexual health], Dock Road, 1993–2000)

Equality doesn't matter to me, I've never been equal rights, equal pay, but if you have a go, the lads leave you alone. As far as they're concerned this is a male environment and if you're not prepared to have a go then what are you doing here?

(Carol, tower controller, Royal Seaforth Container Terminal, 1998–)

My mother was never there for me so I looked after myself. Then a neighbour, an older woman, took me down the dock road when I was 14, and I met loads of seamen, Greeks and Filipinos and that's how I got into it... that's the only life I knew, I brought myself up on the docks. I was getting all this attention from these men, I thought I can do this forever... all the older girls used to call me Miss Chocolate because if they call you chocolate it means you are not getting paid. I used to come off the ships with bags of make-up and tapes and that. At first I was scared to ask for money in case they beat me up, but you learn.
(Mary-Jane, good-time girl, Dock Road, 1978–)

The Captain was annoyed because he was supposed to report to the consul, and he didn't, he sent a delegation, and I saw the delegation, and I spoke to them, but I was very annoyed with the Captain, so I told the men, I said look here it's not your obligation to come and see me, it's the Captain's obligation, and do you mind going back to the Captain and telling him that I want to see him. Because I said that I wanted to see him, he had to come, and I said, look here, I'm not here to make life miserable for you or for anybody else, but it's a Captain's duty to come to the consul. He said, well I don't like a woman consul, and I said, well you haven't got to look at a woman or a man, you have just to look at a consul and the consul embodies the law, as far as you're concerned. He ended up eating out of my hand, and ever afterwards he was always very favourable.
(Gladys, Panamanian Consul, 1952–1970)

I loved going to bed and waking up in a different place.
(Sandy, hairdresser on the ships, 1970–1977)

We made a fool of ourselves on the first day, me and Pauline, cos we went on the same training course and started on the same day, and I said you know first day, wear a suit, and me stepdad said, no it's not that kind of environment, anyway first day, me and Pauline turned up in suits! We looked at each and thought, we should have worn jeans. We made a show of ourselves, two girls turning up in suits to work in a shed.
(Donna, Customs clerk, Royal Seaforth Container Terminal, 2003–)

They hired women because of equal opportunities; it was to fulfil an obligation. They haven't made any real concessions to us, we are stuck down there in the shed. If you want to use the women's toilets you have to come in here and queue to get a key from the canteen or go over to the office, and that's regardless of the weather.
(Julie, export clerk, Royal Seaforth Container Terminal, 2003–)

We get all sorts of people coming here; we have people from Wales who stop off here on the way to Southport. Some of them are disabled and have problems getting out of a car so we go out and serve them bacon and eggs.
(Mandy, Gary's Scran Van, Stanley Dock, 2003–)

The Port of Liverpool Police advertised in the *Echo*, apparently I was the only female in the first 1,000 applications. It wasn't formed, it was a brand new force only formed in the June of 1976, and I was in the third intake... my dad was a policeman, so maybe it was in the blood, and I knew that I didn't want a regular 9 to 5 job. Over the years they have had about ten women join, but none of them stayed any length of time, mainly they left to have families... we've got two new female recruits now and they are the first women in fifteen years, before that it was just me, I was the original Dockyard Dollie as the *Echo* famously called me, I've never lived that down.
(WPC, Port of Liverpool Police, 1976–)

I was born in 1936, so my early childhood was the war, going to school with your Micky Mouse gas mask on your arm, getting up to rubble and noise and shelters, no sweets, no chocolate, your mother going out at half past seven on Friday because she insisted on having fish for the main meal and standing in line at the fishmongers to see if he had a catch that day or didn't have a catch that day. It wasn't very pleasant, it wasn't, er, lovey dovey and isn't life wonderful. My father was very selfish and very much work to bed and bed back to work. I don't have this all round a scrubbed table happy memories I'm afraid, I hated where we lived, always hated where we lived. I hated it because as I started to grow up I wanted flowers, I wanted a bathroom, I wanted warm, it was always draughty and cold, I just hated it. I used to go to my auntie's in Huyton and it was really nice there, you could have a bath on your own, you didn't have to drag the tin bath out and lock the kitchen door, and they had a really small garden in the front, but I thought that was luxury. I always thought there was better, I think that's why I started travelling, because I always thought there was better.
(Bretta, stewardess, 1968–1976)

You can build a business on tea, the quality of your cup of tea is everything.
(Marie, supervisor, McConnell's Canteens, 1957–1982)

When you painted the railings, you could see all the soldiers' names scratched into the wooden rails, lads going home or going out, you wondered whatever happened to them... I never thought about taking a man's job or anything like that, well they weren't there were they?
(Mary, ships' painter, 1940–1943)

There is a final frontier and it's just beyond the dock wall there and it's a place where people can cleanse their mind and find who they are and find achievements in a community that does not belong in twentieth-century life. You know the distance, the cultural distance between us and those trendy bars up on the quay inhabited by minor Hollyoaks stars is huge, there is a vast cultural gulf.
(Sue, ship's master, *Zeebu*, 1996–2006)

All I can remember of the warehouse is sacks up to the ceiling, when you would go to the toilet the bags would be piled up from the machinists, they were on piece work.
(Margaret, worker, bag warehouse, 1946–1947)

Hopefully things are going to pick up with this City of Culture thing that we're in. There's a lot of money getting ploughed into Liverpool, and I hope some of it comes down to this end of Bootle.
(Anne, owner/manager, Blanche's Café, 1990–)

I was a clippie, and my job was to give the dockers a ticket for sixpence, but them dockers! They used to hand it like that and then pull it back fast. I used to say to the inspector, I'm not going up there no more. They used to say, truthful! They used to say, 'giz a feel of your leg girl', we used to have skirts then, but then we got trousers!
(Maria, tram clippie, Dock Road, 1945–1947)

No one takes any notice of prostitution on the Dock Road, it's just like going for milk to the supermarket.
(Christine, barmaid, The Talbot, 2002–)

Even though you are doing the same thing every day, it's different, we get the cars coming in that have to go out for export, and we have to drive them to the car pound. One day the police cars came in to be sent to America, and we drove them along with all the sirens going, all these cars pulled up at the side of the road to let us past, and we all jumped out like it was a raid, that was a real laugh. You can have a laugh.
(Pauline, import clerk, Royal Seaforth Container Terminal, 2003–)

My grandmother brought me up after my mother died at the age of 22 years. She worked very hard; at one time she was a dockworker moving trucks of nitrate soda. I never saw my father again after he went back to America but we heard he had married again about ten years after my mother had died.
(Mary, cook, WRNS, 1943–45)

A lot of people would say that I get a lot of sexual harassment at work, but I just say that they're sad, and I give it 'em back. When the fellas say, 'go on show us your boobs', I say, 'you show me yours'. I don't know if he had to employ a certain number of women or not. I was originally put to work as a checker, checking the wagons in and that, but I said I want to drive a fork-lift, and he went, yeah, yeah, I said, I want to drive a fork-lift... I trained in my own time for that, and the Dock Board passed me out on a 28-tonner. Then I did the training for the bigger one, a 48-tonner. Basically I got bored checking wagons in.

(Sandra, heavy plant driver, Royal Seaforth Container Terminal, 1995–)

We were mentally and physically exhausted. I'm the type that I lose weight when I'm stressed. I'm a size 10 dripping wet and I went down. I remember I couldn't lie in bed because my bones protruded, all down my back every vertebrae had a red mark on it. I was running three homes, I had two sons at uni and I was trying to keep them stress free, I was looking after my mum and dad, shopping, cleaning and doing nursing care... my dad had had a stroke at this stage. I was running my home on the smell of an oil rag, our car had gone... At the end of the dispute a journalist asked me how I was going to go back to my life as a housewife, and I said, I never left it.

(Doreen, chair, Women of the Waterfront, 1995–1998)

When my husband first left, I had to get this job on the docks, my mother's sister worked cleaning the ships and she got me in. We went down to Porters on Shaws Alley on the Dock Road, we used to go there to this office, and he'd go you, you, you go to such and such a ship, but you didn't always get picked and you'd have to go home again. We'd wear bib and brace overalls. Sometimes we'd get to go to the Herculaneum Dock down this end which was handy for me, because you only had to go down the steps. They'd have little ships there that you'd work on for two or three days washing the paint, just washing the paint, that was poor money, it wasn't as much as labouring. For labouring we used to go on the liners, well they were troop ships then. Labouring was mostly sweeping up. When I worked on *The City of Edinburgh* we were lagging pipes, the ship was going to Russia and I was put to work with this man, the lagger. He used to put the asbestos on, and then the canvas on top of that, and I used to stitch the canvas to the pipe. I was on there for a couple of weeks. I worked on *The Orion*, just brushing up after the joiners. Of a dinnertime, we used to sit up on the main deck with the men, playing tombola as they called it in them days, they didn't call it bingo then. After one o'clock we all went back to work, and then at five o'clock get The Overhead home.

(Doris, ships' cleaner, 1943–1945)

It was an experience; I'd never been on a ship before. It was a lovely view, looking all round the Mersey like that, because the Mersey was something back then, looking at all the other ships lined up… It's always been on my mind, that experience.

(Dolly, bag warehouse worker, 1937–1938, ships' cleaner, 1946–1947)

They'd go out at seven in the morning and work till seven at night and then go in the pub after that. She loved the work, she loved it and she got the money and they'd never had money like that in their lives before had they? It was freedom for them. They were able to go where they wanted; they went on charabanc trips, anything from the pub. She was never out the pictures, her and Nelly, she lived two doors away and she was on the ships as well. It was like as though that was their little army and they were like rebelling against the years that they'd had. They'd had hard lives… I think they might have earned about £3.00 a week, but I'm not sure. They were employed by Harland & Wolff, or that's who they worked for anyway. She worked seven days a week, half-day Saturday but she used to go the pub till it shut at three. She only really calmed down when my dad had the stroke. I had to go running to get her out the back parlour of the pub, and I remember her taking my hand as we went over the Iron Bridge and she said, 'promise me you won't tell anybody I was in the pub, promise me', and I never did. She was rough in a way, but she was good as well. We used to say, it was the ships that ruined our mam, it was the ruination of them, they ruined our family life, what we had. They started putting clothes on their back, because years ago they wore a shawl, they didn't get dressed up. The war was like liberation really for a lot of women really, it changed how they worked and opened up their world.

(Teresa, daughter of Emma Lochren, ships' cleaner, 1941–1949)

They used to call me Tiny Tears because I'm very emotional, I used to cry all the time, you used to go into town and see people collecting for the dockers with stickers on, and my heart used to break thinking, oh they look well-to-do, and they're supporting us, and it used to bring you back to think, you should never assume that it's only the working class who care.

(Sue, secretary, Women of the Waterfront, 1995–1998)

I got a job on the Belfast car ferry as a hostess, you just looked pretty and took tickets, did that for a couple of years, and then some of the people who came on the ferry were women who had been home for a bit and were going back onto another ship, deep sea, and one of them said, there are jobs going with the Shaw Saville Line, but you had to be a first-class waitress and have five years' silver service experience, so I wrote to them and told them all about my years of silver service experience. I had none. I got the job, and once they'd sailed, there was nothing they could do.
(Miriam, stewardess, 1970–1989)

I was in Ships Company; I used to deal with records for the drafts that came in every three weeks. The training camp was next to Burtonwood where the Americans were stationed. It was great fun, they were very good to us, and they used to send a big army lorry over every Saturday night to bring us over to the dances there at the base. We only went for the good food they gave us; they had big burgers and strawberry milkshakes and nylons! They were lovely lads, just like us, and homesick. They didn't want to be in the war like the rest of us. Of course all the B17 bombers were coming in there, and on D-Day they all went to Normandy, and a lot of them, of course, never came back.
(Mary, writer, WRNS, 1942–1946)

Two of the stewards used to attend our women's meetings, to liaise... they had this thing that they would discuss tactics... they came up with this plan that the men would all go to Bernard Cliff's church on a Sunday dressed in yellow coats. I didn't want any part of it... I could talk to our priest here in St Patrick's about the dispute and what was going on. He used to go and see the Archbishop and there were a couple of things you couldn't talk to the Archbishop about, one of them was the dockers. As soon as he walked in 'the Arch', cos this is what they used to call him, said to him, 'how's the dockers doing' and he tells him the update. Along the lines that I'm thinking we've got 'the Arch' on our side, why do we want to upset the church, I'm thinking if I can liaise with my priest, and get him to liaise with Bernie Cliff's priest, maybe we can get a conversation going. So the men went, well if you can sort that out Anne, we'll leave it with you. So I did the necessary... Bernard Cliff rang me here. I'm under no illusions that I can negotiate for 500 men, so I'm doing this as a plea, give these men their jobs back, take them back. The men were livid. At the men's meeting on the Friday, one of the stewards got up and said, 'no-one will negotiate on behalf of these men, only us stewards', I thought if that's not a dig, I'll eat my hat, and I thought yeah, so I got up and said, 'Anne got sent on a message, and Anne came back with the shopping.'
(Anne, vice-chair, Women of the Waterfront, 1995–1998)

I was hired by Drakes to re-form the labour force during the dispute... I thought about it strategically, hiring women, that that's what I would do. I wanted a new start and the way I saw a new start was to employ a different type of person and the best way to do that was to employ women, and it's made a huge and significant difference. There was always conflict between the drivers and the clerks in R&D, when the lorries came in, so I thought that one of the ways to take the conflict out was by putting women in there. The interaction between the sexes cuts out the hostility. I must say they've done extremely well, sickness is very low and they tend to be very loyal to the job.

(Les, operations manager, Drakes International, 1995–)

The whole atmosphere here now is different, there's no respect, in the old days the dockers were rough and ready but they wouldn't swear if a woman was around like these do. The language in here is terrible, but I have a no swearing rule once they get up near my counter.

(Cathy, catering manager, Royal Seaforth Container Terminal, 1992–)

At sea, you can't have any secrets.

(Miriam, stewardess, 1970–1989)

Photographs: Michelle Sank

Kitty
Docker

Wallasey

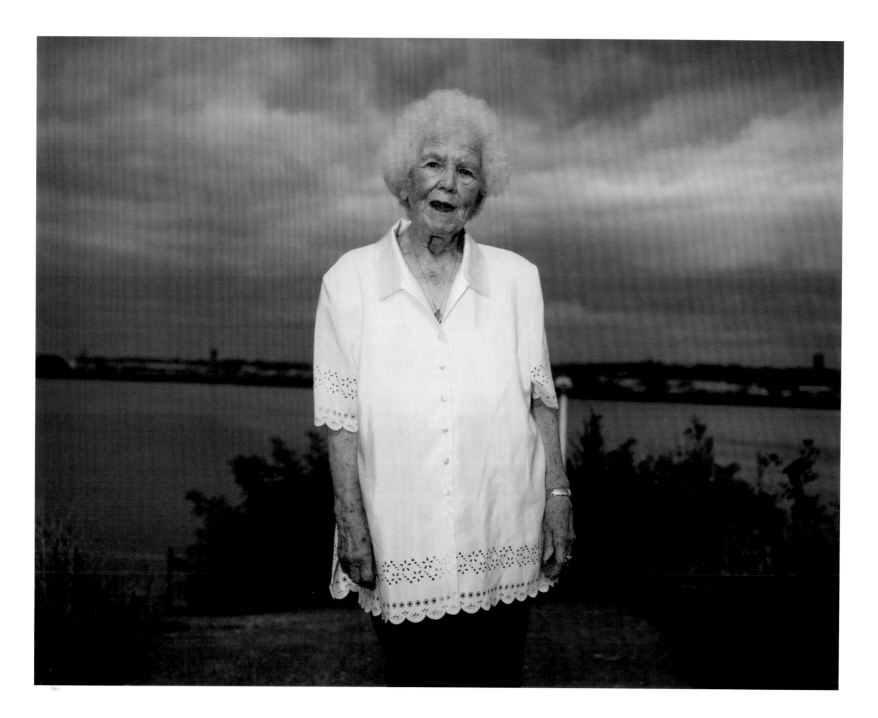

Mandy and Charlene
Catering assistants, Gary's Scran Van

Stanley Dock

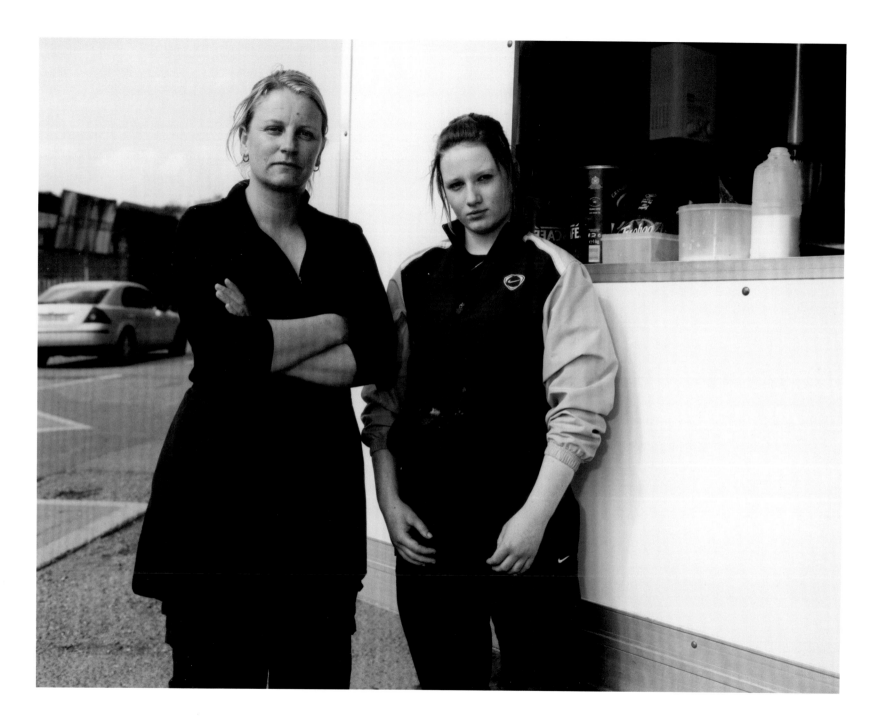

Sandra
Heavy plant driver, Royal Seaforth Container Terminal

Royal Seaforth Container Terminal

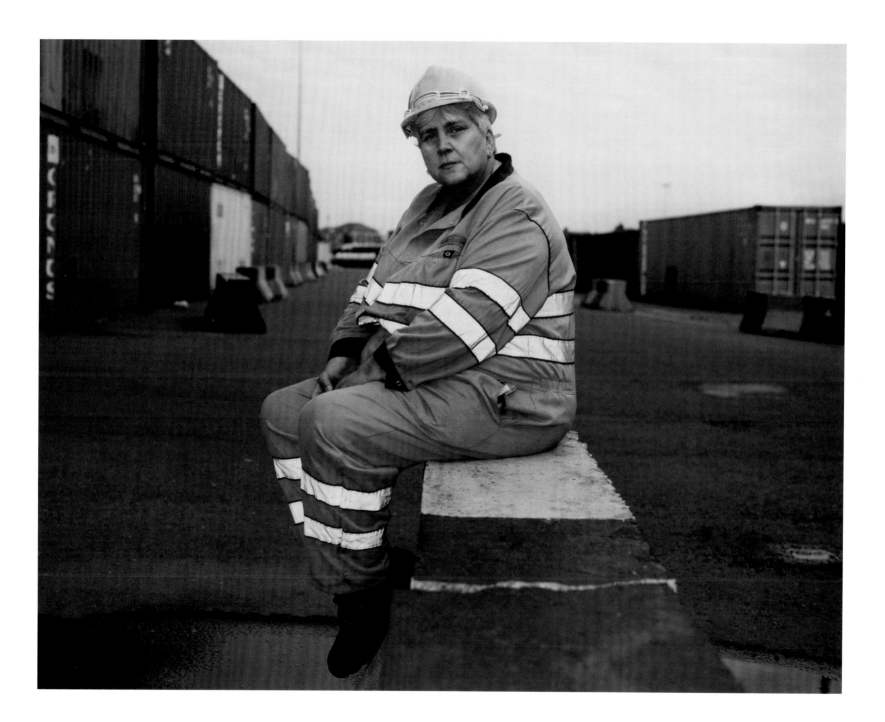

Dolly
Ships' cleaner, bag warehouse worker

Vauxhall

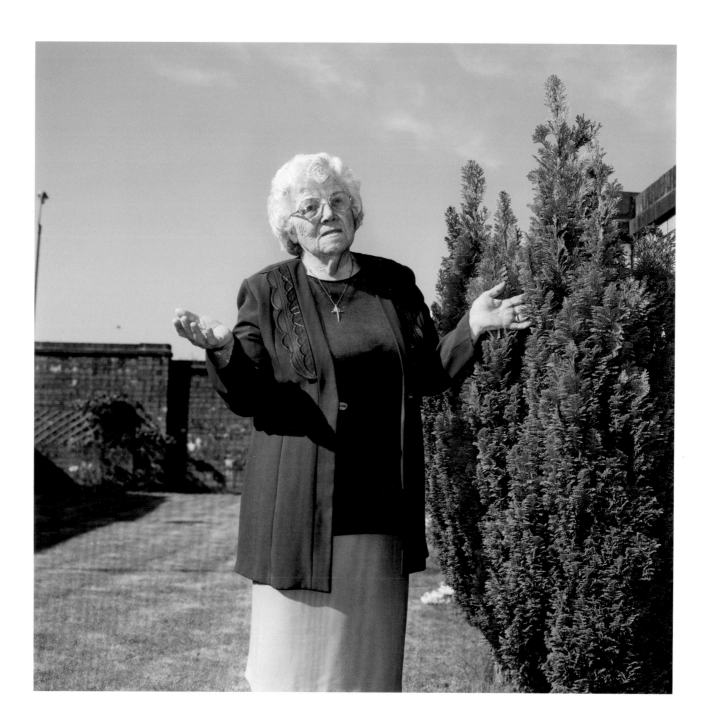

Emma

Customer service supervisor, Isle of Man Steam Packet Company

Isle of Man Ferry

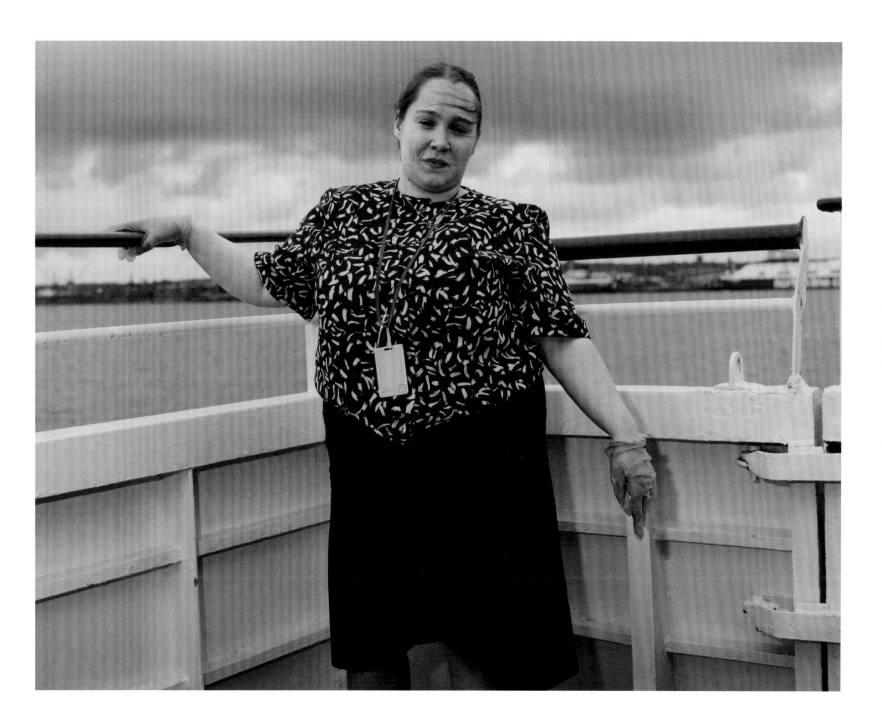

Cathy
Dock canteen manager, Royal Seaforth Container Terminal

Royal Seaforth Container Terminal

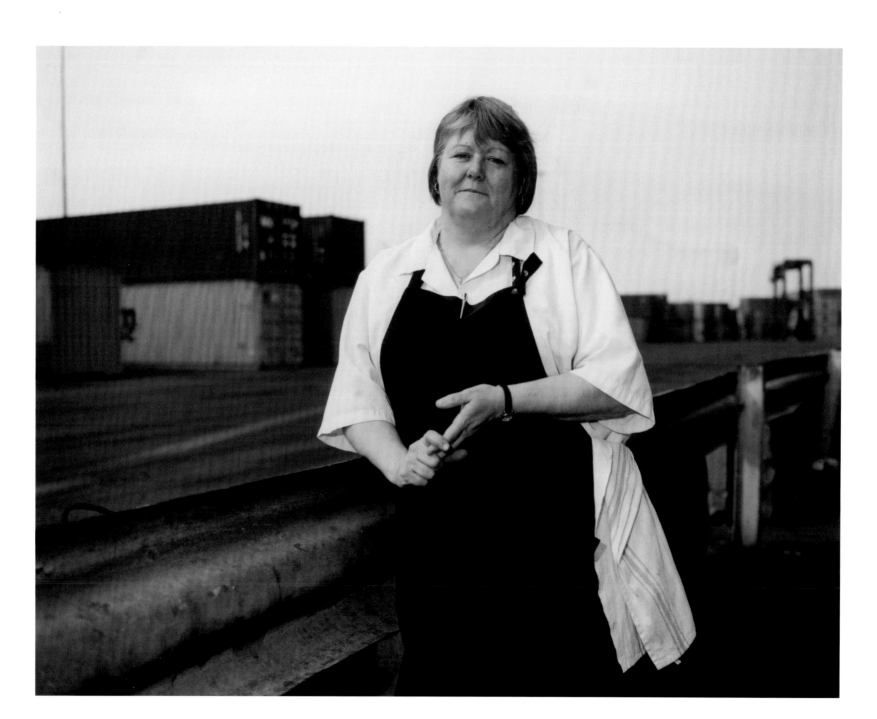

Christine
Barmaid

Hartley's Bridge

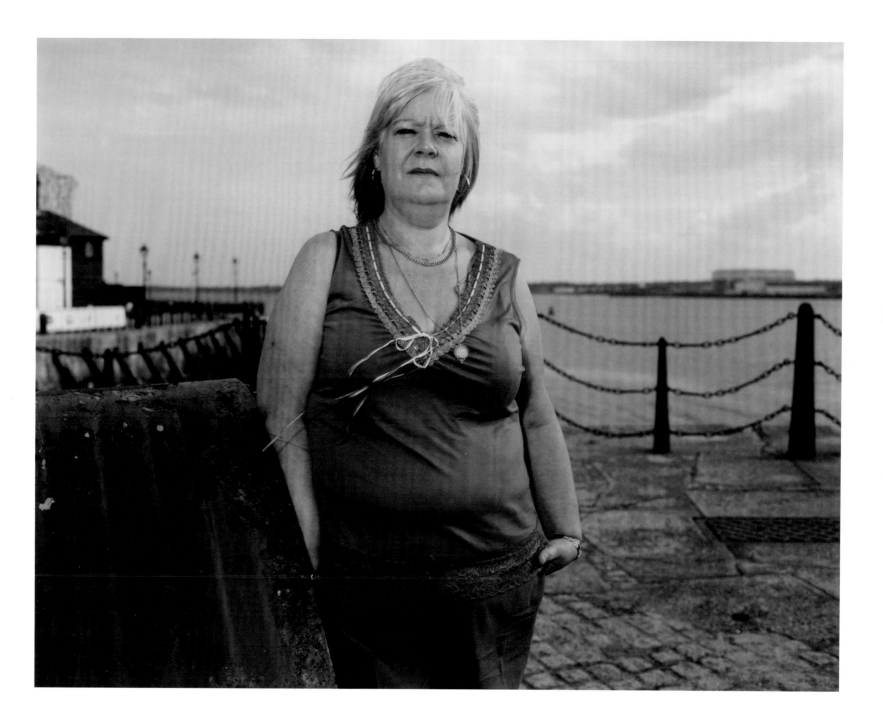

Mary-Jane
Good-time girl

Kirkdale

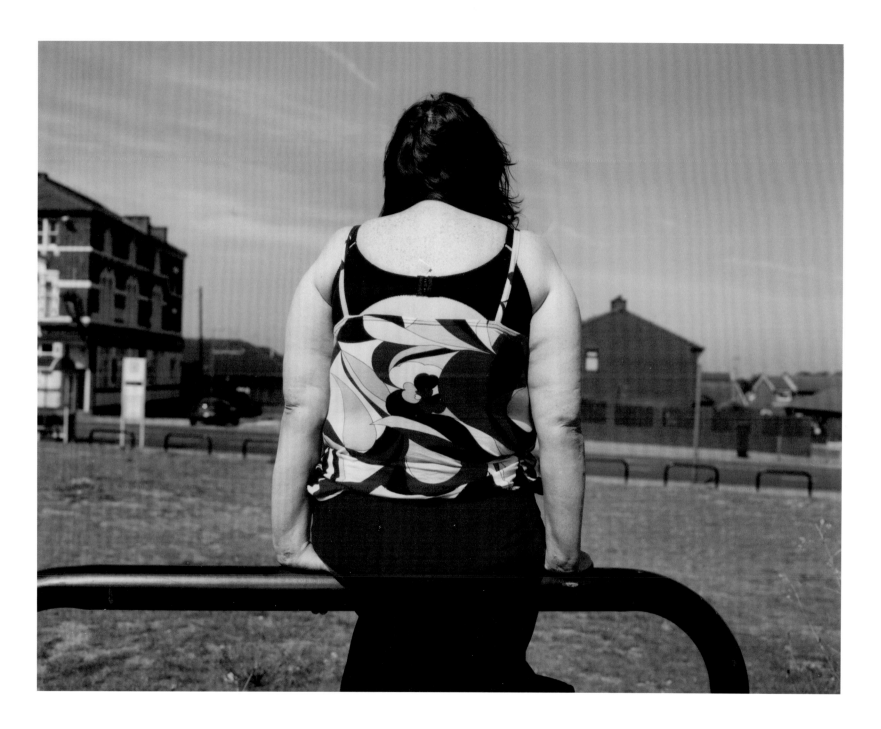

Glenys
Bar manager, Mersey Mission for Seafarers

Seaforth

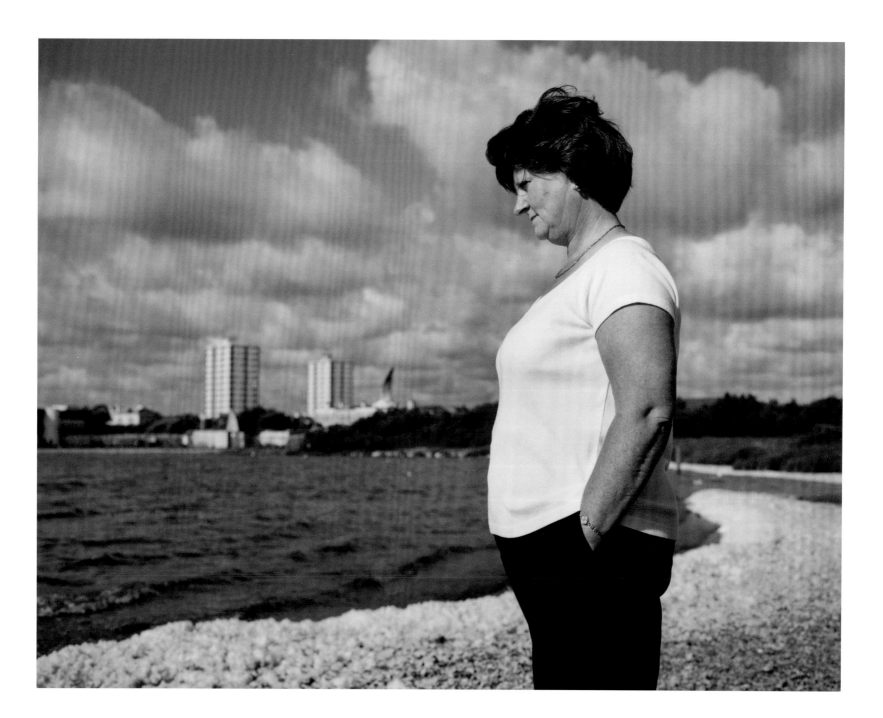

Carol
Tower controller, Royal Seaforth Container Terminal

King's Parade

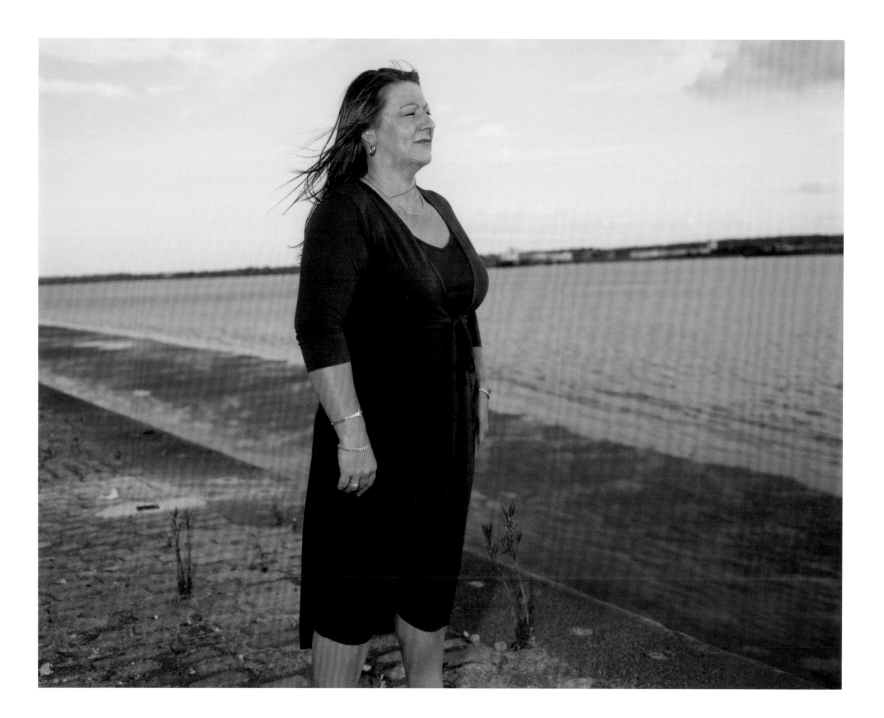

Mary
Ships' painter

Knotty Ash

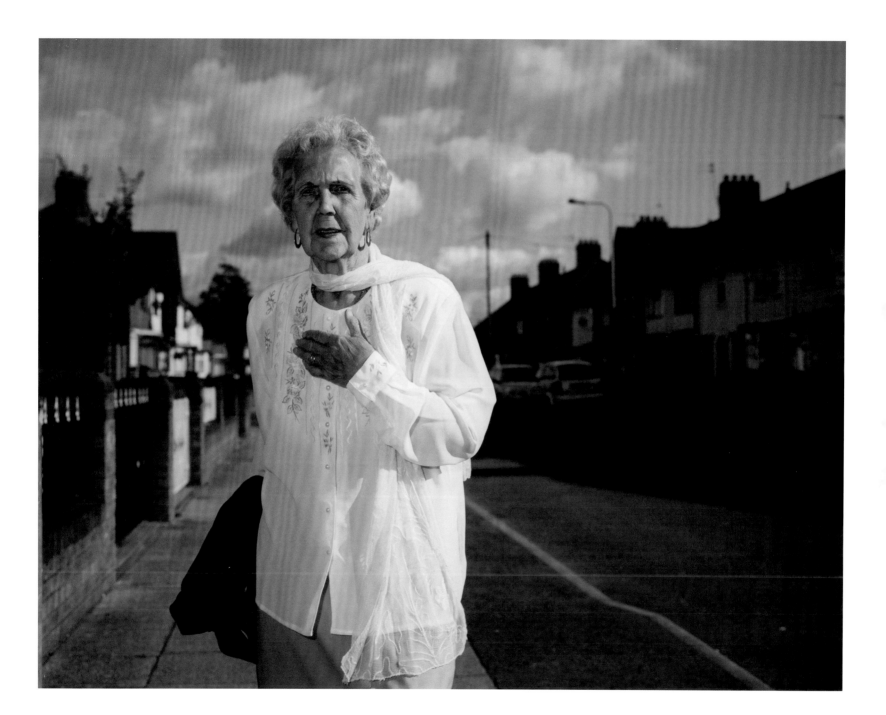

Bretta
Stewardess

Kirkdale

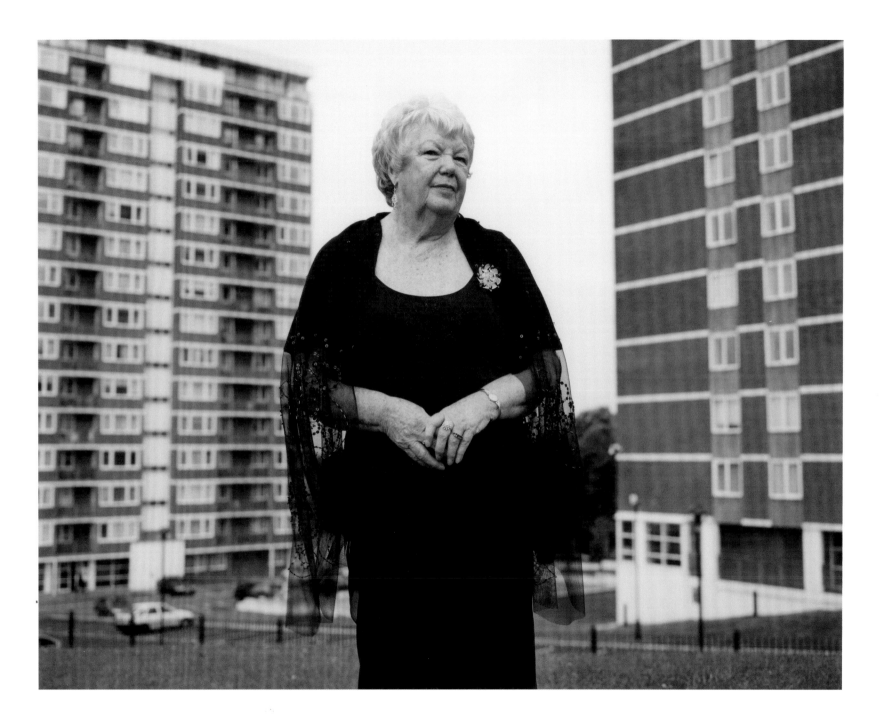

Lorna
Stewardess

Hightown

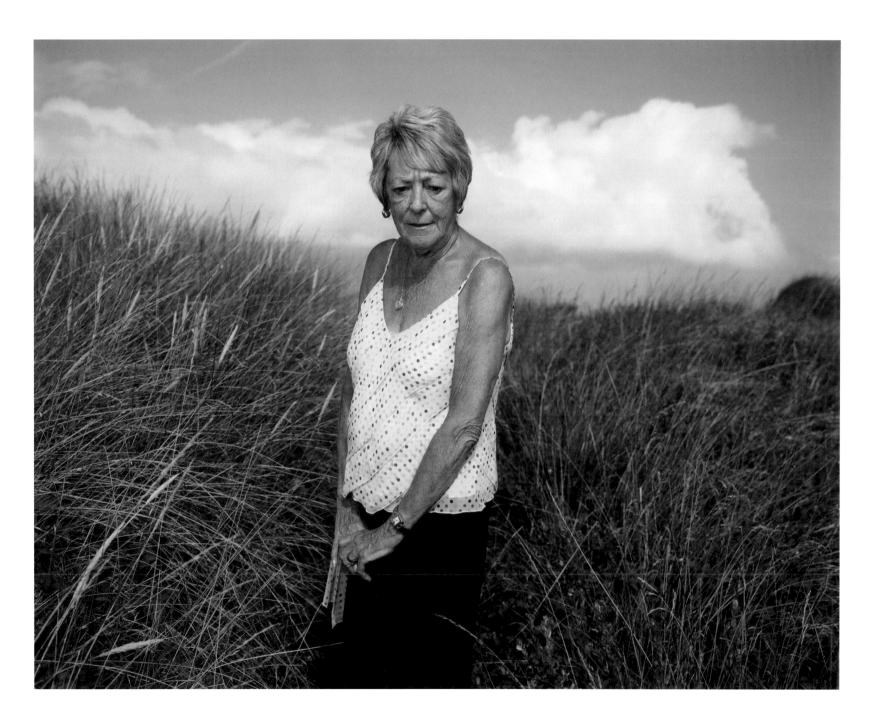

Sandy
Hairdresser on the ships

Birkdale

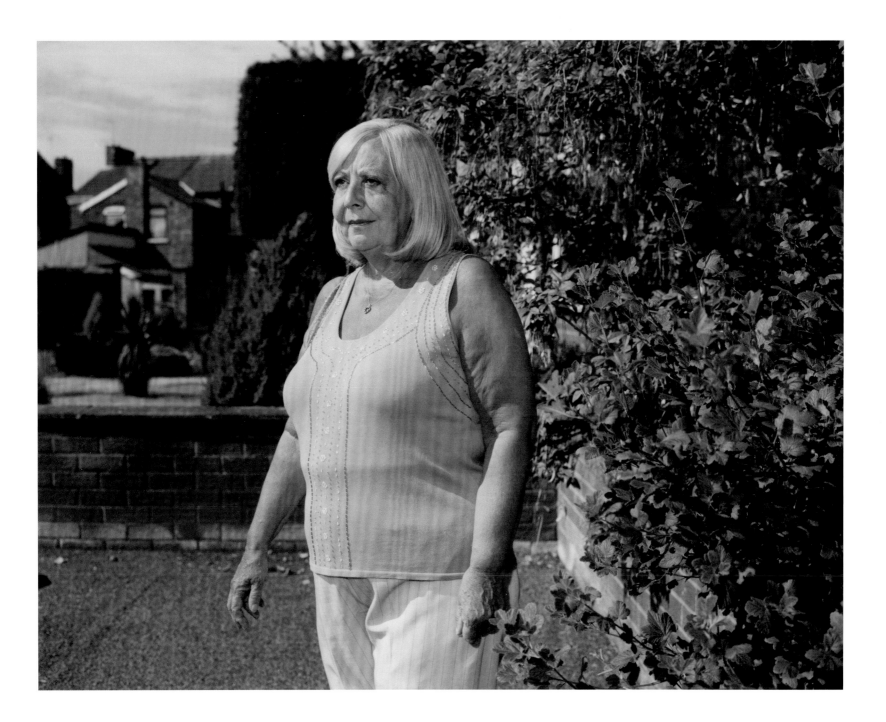

Marie
Barmaid

Dock Road

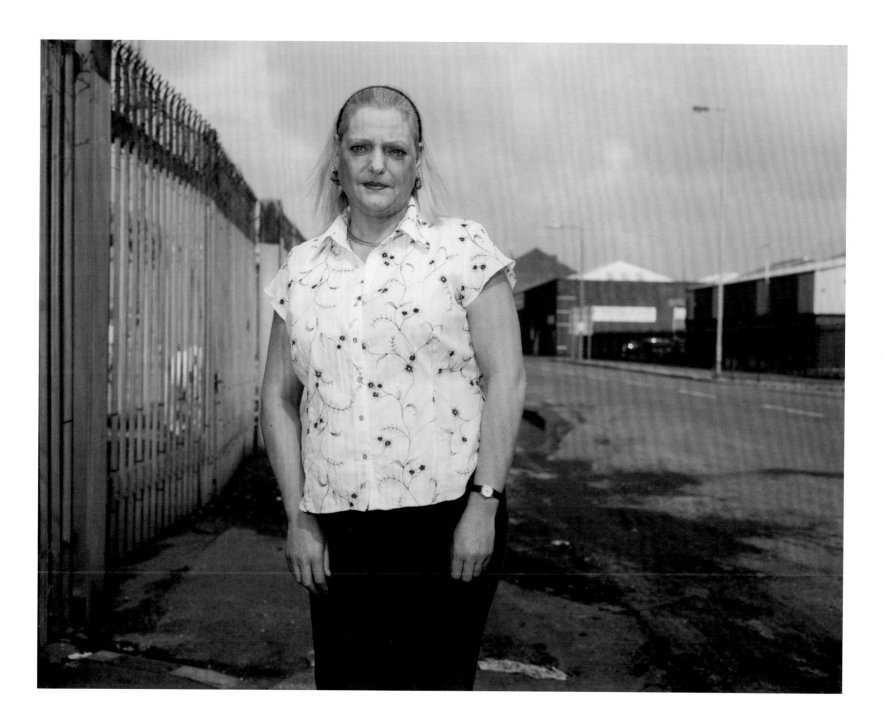

Miriam
Stewardess

Hale Village

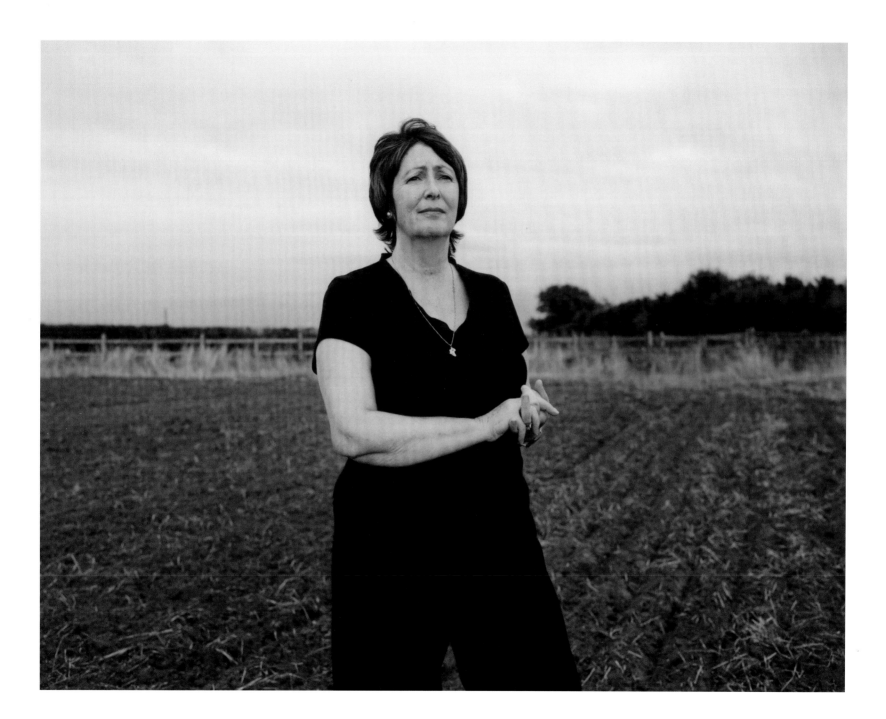

Betty
Barmaid, Mersey Mission to Seafarers, and retired stewardess

Seaforth

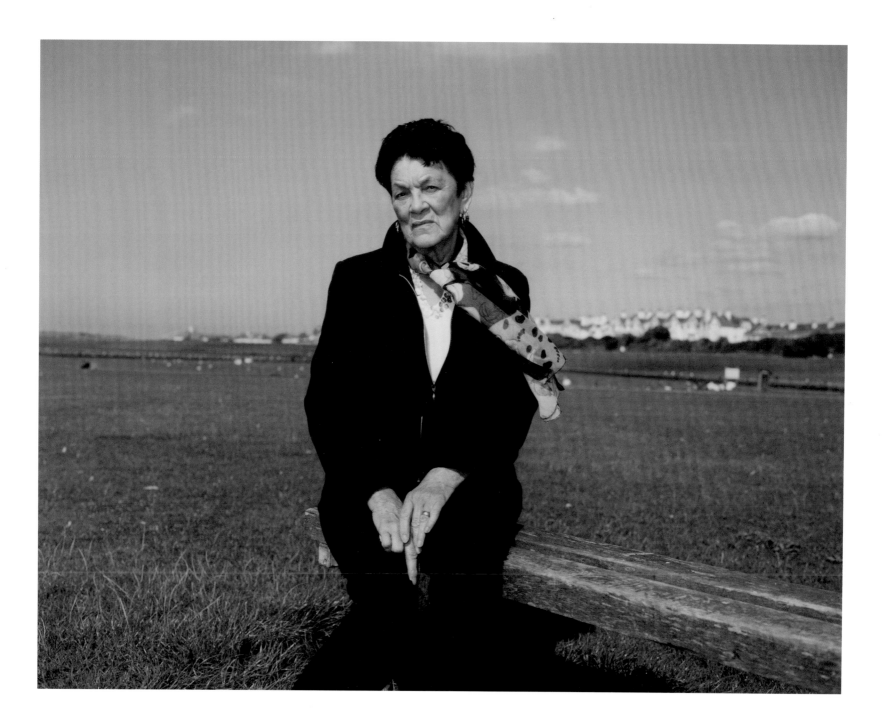

Doreen and Sue
Chair and Secretary, Women of the Waterfront

Pier Head

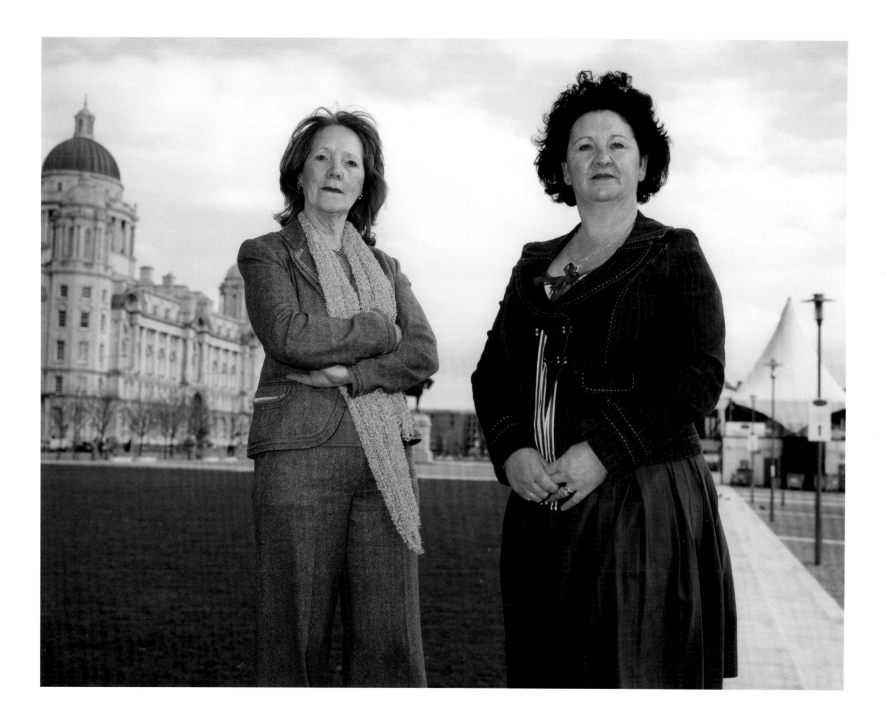

Linda
Project worker (sexual health)

Bootle

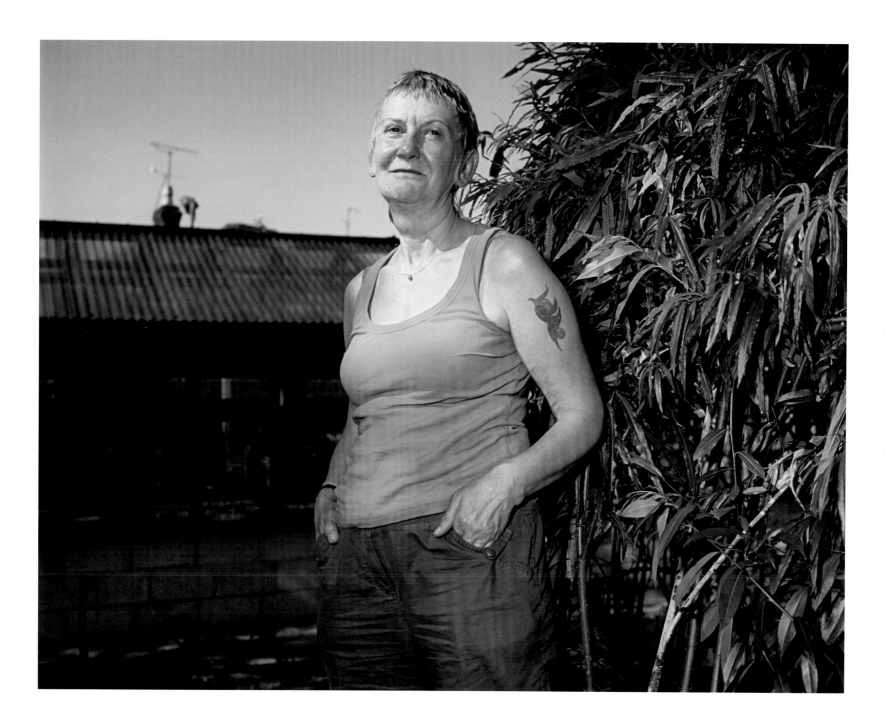

Maria
Tram clippie, Dock Road

Bootle

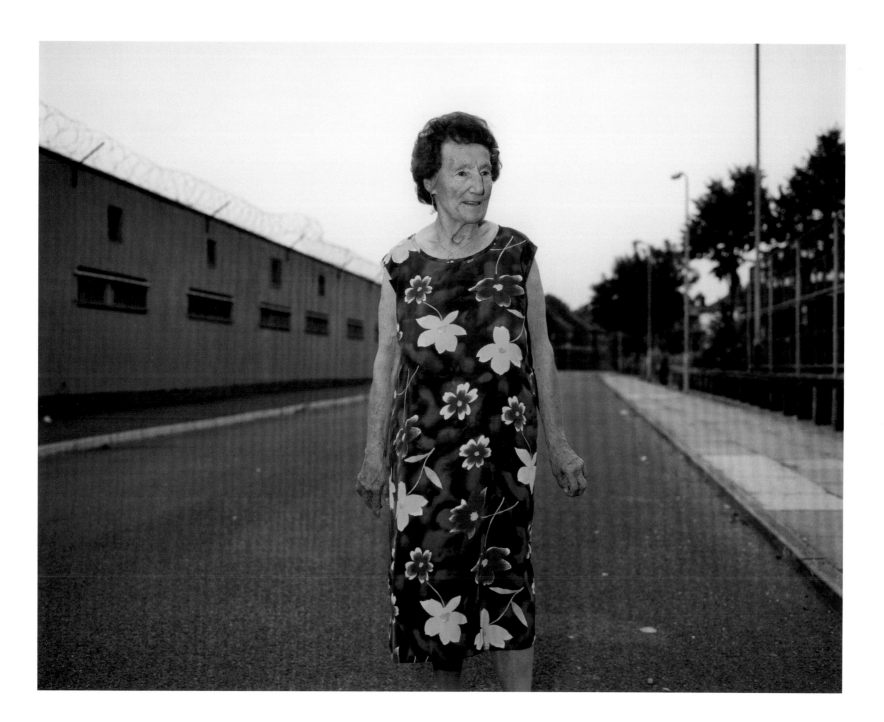

Nicola and Lyndsey
Customer service assistant and customer service officer,
Isle of Man Steam Packet Company

Isle of Man Steam Packet Company Terminal, Princes Parade

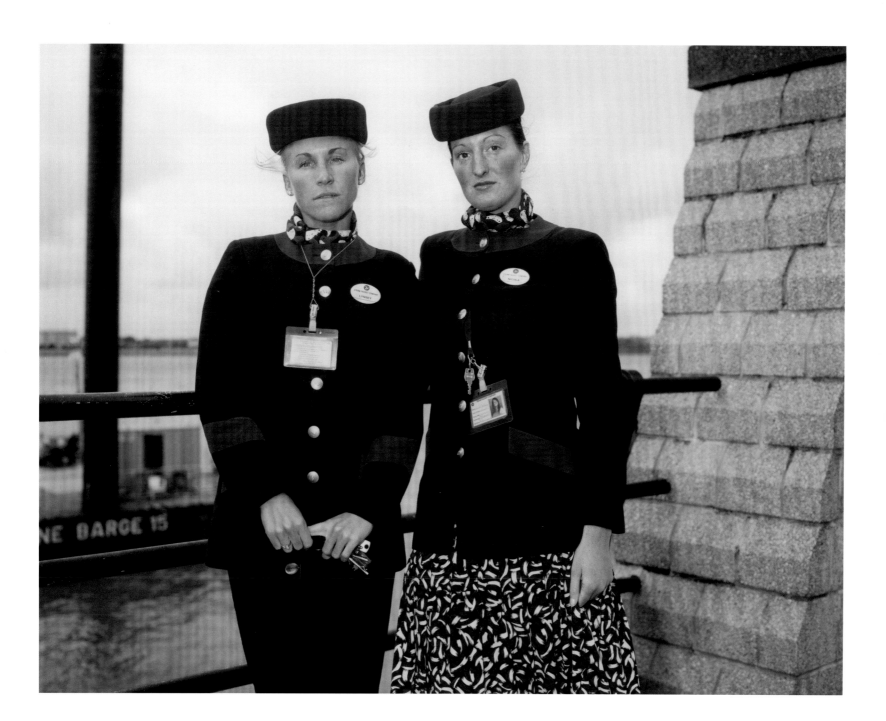

Maureen
WPC, Port of Liverpool Police

Royal Birkdale Golf Club

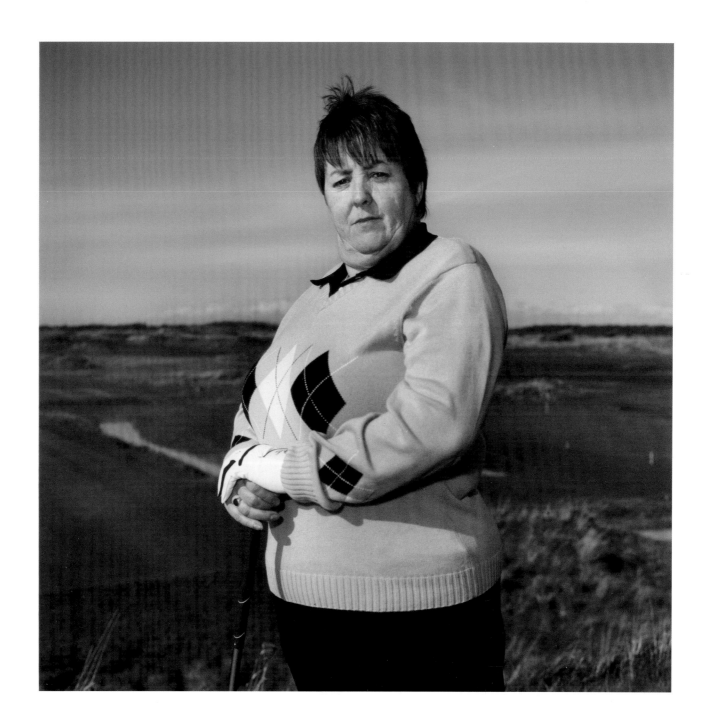

Pauline
Import clerk, Royal Seaforth Container Terminal

Albert Dock

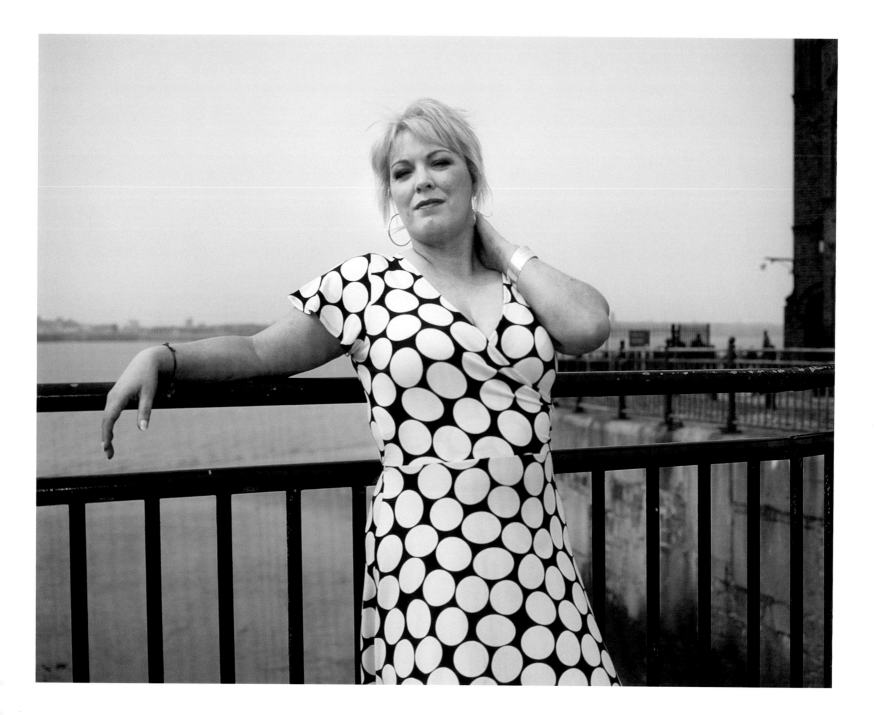

Mary
Women's Royal Naval Service

King's Parade

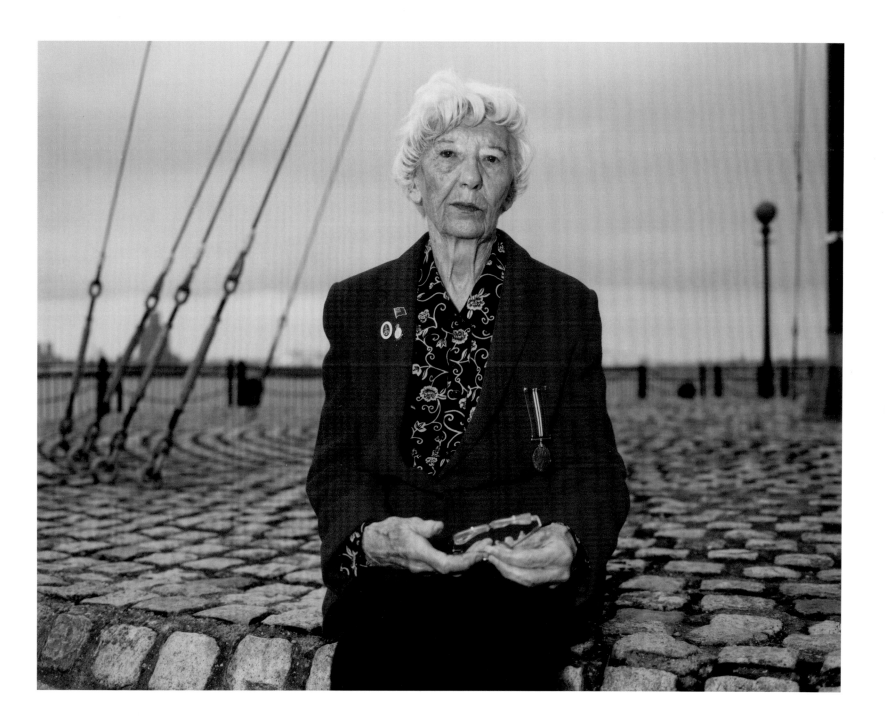

Blaze
Dancer

Merchant Navy Memorial

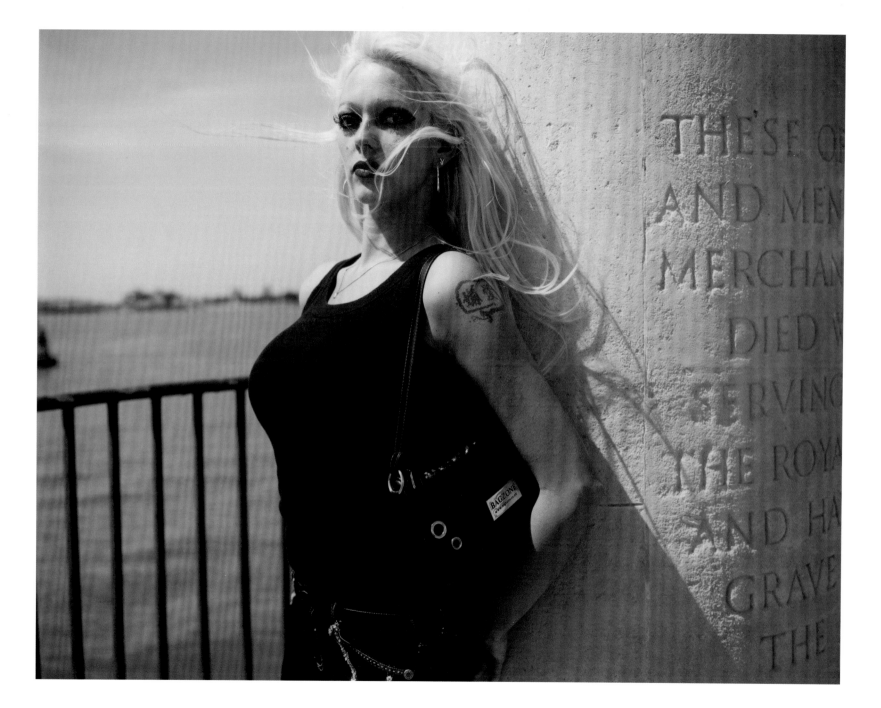

'In a Man's World': Michelle Sank's Women of the Liverpool Waterfront

Roy Exley

> The human being is masked, and the most difficult subject to capture is not so much their reality or
> their resemblance, as their mask, or in other words, their secret identity or alterity. [1]
> Jean Baudrillard

[1] Jean Baudrillard, 'The Art of Disappearance', in Nicholas Zurbrugg (ed.), *Art and Artefact*, London, Sage Publications, 1997, p. 29.

Michelle Sank's portraits for *The Water's Edge* project mine a rich, and previously neglected, vein of history. While the dockworkers kept the country's supply lines flowing or, on occasions, brought them to a grinding halt through industrial action, and had reasons to be proud of their efforts, the stories of their female counterparts were overlooked. Just as August Sander, the German social documentary photographer, brought recognition to ordinary workers and tradespeople through his portrait work in early twentieth-century Germany, so Sank is helping to bring belated recognition to the women who work or worked on or near the Liverpool docks, or who have departed from them to work at sea. The narratives of these women, etched into their facial expressions, are as dramatic as any contemporary soap opera. With the exception of Sank's images of Mersey Ferries' stewardesses, Sandra the heavy plant driver and Cathy the dock canteen manager, however, there is no evidence in their attire of their working lives. Sander, of course, liked to show his subjects dressed in their workwear and holding the tools of their trade, as if they had paused from their work merely for the duration of the photograph. Sank, for the most part, has given these women the freedom to choose a mode of dress in which they like to be seen, in which they want to be seen. This is symptomatic of the sympathetic way in which she has approached this photographic project – she has been able to engender a mood of quiet self-assurance in her subjects. So often in contemporary portrait photography, such as the fragile teenage bathers of Rineke Dijkstra, the anomie-stricken teenage girls of Hellen van Meene, or the resigned elderly of Magali Nougarede who are seeing out their last days, the subjects look vulnerable, insecure, uncertain of their place in the world. In contrast, many of Sank's subjects, looking out beyond the frame into the distance, have an almost heroic demeanour – their poses would have done justice to the social realist statues in communist Russia.

There is little that is stereotypical or formulaic about these posed portraits (except for the fact that most, paradoxically, are landscape rather than portrait format and few show the legs and feet of the subjects) but neither is there anything new or radical about the way that Sank has approached them. It is as if these subjects have imposed themselves in their own particular way on these photographs, while unsure, somehow, of what was expected of them. Nothing revolutionary here as far as the photographic portrait is concerned – more

staged perhaps than Jitka Hanzlova's candid photographs of the women of Brixton and more personal and empathetic than Albrecht Tübke's 'Citizens' – a series of 'cold-called' posed images of people in the streets of European cities. Interestingly, a few whimsical idiosyncrasies rear their heads in Sank's images, as if to ward off any sense of self-importance that might creep in. For instance, Miriam, an ex-stewardess from the ocean liners that used to sail from Princes Landing Stage, dressed in a smart trouser suit, is standing in the middle of a newly ploughed field. We are unable to see her lower legs or feet, so we can't tell whether she is wearing wellingtons or court shoes. Dolly, who used to work at a bag warehouse, stands alone in a suburban garden with her arms half raised as if she is about to launch into a cabaret act; only she can know the significance of this pose. Bretta, another ex-stewardess from the ocean liners, seemingly dressed for a night out at the opera, is sandwiched, incongruously, between the forbidding masses of two sixties tower blocks. The poses are unspectacular – they are individual, idiosyncratic, unforced yet somehow constrained by the sense of occasion. The backdrops, while equally undemonstrative, are far from arbitrary; no two are the same but in their totality, like pieces in a jigsaw puzzle, they give us a picture of the environment and the hinterland of the Liverpool docks that forged the lives of all of these women. In a similar but paradoxical way, while individually these portraits betray little, collectively, as a series, they connote so much.

Despite the North-West's reputation for being constantly rain-soaked and grey, Sank managed to find a good deal of fair weather beneath which to shoot these portraits, and that, along with her use of fill-in flash, gives these images a bright, optimistic lightness. Like the sanitised, well-polished memories of sunny childhoods that some of us carry around with us, it is as if all of those dark and gloomy moments, those tough decisions and discomforting events, those times of grief that punctuated their lives, have been airbrushed away. Ultimately, however, the faces of Sank's subjects betray the rigours and trials that these women have met along the way.

These photographic portraits navigate the boundaries between self-portrayal and real identity. The way these women present themselves to us, their choice of clothes, their very particular hairstyles, their awkwardly relaxed poses, are masks behind which they hide, attempts to convey more-or-less idealised images of themselves. The controversial American portrait photographer Diane Arbus once said 'Our whole guise is like giving a sign to the world to think of us in a certain way, but there's a point between what you want people to know about you and what you can't help people knowing about you.'[2] We can sense, through many of Sank's images, a slippage of those masks – unguarded expressions offer us a revelatory suite of evidence, slipping over onto the 'real identity' side of the boundary, telling a thousand tales, providing subtle, subliminal, but undeniable visual narratives. The story that Sank's photographic project tells is, basically, one of neglect, of oversight; this is a mission to put the records straight.

2 Patricia Bosworth, *Diane Arbus: A Biography*, **New York, Norton, 1984.**

A photograph is the fleeting time signature of an event, a particular moment in a specific place, paralysed and compressed, mutely preserved on celluloid or stored on microchip, whose meaning is lost without the framework of its context. Many of these photographs could almost be family snapshots, images of strangers that offer us no immediate access for interpretation, no hook to engage our attention, but given their context in this exhibition, suddenly they open doors in our minds, offer associations for the triggering of memories. We need to capitalise on this opportunity, to seize the day. Just like memories, photographs fade or get consumed by archives, rarely to resurface. We can use this exhibition as a catalyst, follow it up with questions that underpin it and extend its scope. What is the history of women in industry, and in the myriad activities that support and surround it? How do women figure in the history of the Liverpool docks? How, and through whose agency, did their roles change over time? The questions abound, but Michelle Sank's sensitive and sympathetic images of these women, while not seeking directly to answer them, transcend a merely documentary role; they raise our awareness of a neglected aspect of the history of a city whose lifeblood has always been the sea.

Contributors

Joanne Lacey was born and raised in the North End of Liverpool. Born nosy, her great passion is people and the stories they have to tell about themselves and their lives. An academic for many years, specialising in oral history and the media, Joanne has published widely. She now runs Jel Research, a consultancy providing research for private and public sector clients. For more information see www.jelresearch.com.

Michelle Sank was born in Cape Town, South Africa. She left there in 1978 and has been living in England since 1987. Her portrait photographs reflect a preoccupation with the human condition and in this sense can be viewed as belonging to the social documentary tradition. Michelle has been commissioned and exhibited widely throughout the UK. Her recent portrait projects are the subject of *Becoming*, a monograph published in December 2006 by Ffotogallery, Cardiff and Belfast Exposed Photography, Belfast. For more information see www.michellesank.com

Patrick Henry has been Director of Open Eye Gallery since April 2004. He was formerly Curator of Exhibitions at the National Museum of Photography, Film & Television in Bradford, and was a practising photographer, based in Manchester, from 1991 to 1997. For more information about Open Eye Gallery see www.openeye.org.uk

Roy Exley is a freelance art critic and curator, based in London. Specialising in contemporary photography, he writes for such magazines as *Portfolio, Photoworks, Camera Austria, Next Level, Flash Art* and *Blueprint*. He has curated nine exhibitions since 2000, the most recent of which was 'Amplifying Silence / Magnifying Stillness' at the Fondation d'Art Contemporain Daniel & Florence Guerlain, Les Mesnuls, France. He has also been a judge at 'Photosynkiria', Thessaloniki, Greece, and for the BOC Emerging Artists Award.

Acknowledgements

Joanne Lacey would like to dedicate this project to Mary Anne Nyland and Ellen Lacey; thanks also to Liverpool Museums for financial support for 'Working at the Edge of the World', and especially to all the people who gave their time so generously to share their stories.

Michelle Sank would like to thank all the women photographed who allowed her to share a part of their lives.

Patrick Henry would like to thank Sarah Jane Dooley, Fiona Gasper and Robyn Archer of Liverpool Culture Company for helping to fund the commission. Thanks also to Monica Nunez and Stephanie Blundell of Open Eye Gallery.

In memory of Joyce,
who loved the freedom of the sea

Commission supported by